Draw
SKETCHES
Hans Schwarz

A PENTALIC BOOK
TAPLINGER PUBLISHING COMPANY
New York

First published in the United States in 1981 by
TAPLINGER PUBLISHING CO., INC.
New York, New York

Library of Congress Catalog Card Number 79-56743
ISBN 0-8008-2289-7

Contents

Making a start

Learning to draw is largely a matter of practice and observation—so draw as much and as often as you can, and use your eyes all the time. Look around you—at chairs, tables, plants, people, pets, buildings, your hand holding this book. Everything is worth drawing.

This book is about sketching and gives advice on both *how* to sketch and *what* to sketch. Sketching can be defined as drawing speedily direct from a subject in an attempt to give as much information as possible in a limited time.

Carry a sketchbook with you whenever possible, and don't be shy of using it in public, either for quick notes to be consulted later or for a finished drawing.

To do an interesting drawing, you must enjoy it. Even if you start on something that doesn't particularly interest you, you will probably find that the act of drawing it—and looking at it in a new way—creates its own excitement. The less you think about *how* you are drawing and the more you think about *what* you are drawing, the better your drawing will be.

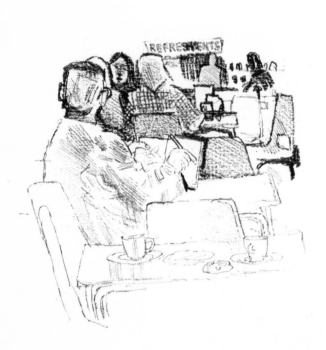
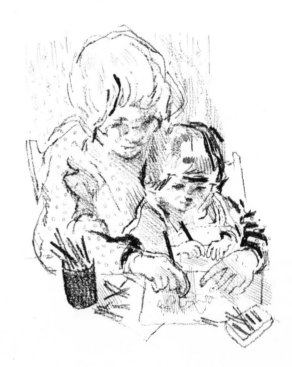

The best equipment will not itself make you a better artist—a masterpiece can be drawn with a stump of pencil on a scrap of paper. But good equipment is encouraging and pleasant to use, so buy the best you can afford and don't be afraid to use it freely.

Even if you think you have a gift for tiny delicate line drawings with a fine pen or pencil, be as bold as you dare. It will act as a 'loosening up' exercise and the results may surprise you.

Be self-critical. If a drawing looks wrong, scrap it and start again. A second, third or even fourth attempt will often be better than the first, because you are learning more about the subject all the time. Use an eraser as little as possible—piecemeal correction won't help.

Try drawing in colour. Dark blue, reddish-brown and dark green are good drawing colours. A coloured pencil, pen or chalk can often be very useful for detail, emphasis or contrast on a black and white drawing: for instance, in a street scene, draw the buildings in black, the people, car, etc. in another colour. This simple technique can be very effective.

You can learn a certain amount from copying other people's drawings. But you will learn more from a drawing done from direct observation of the subject or even out of your head, however stiff and unsatisfactory the results may seem at first.

A lot can be learned by practice and from books, but a teacher can be a great help. If you get the chance, don't hesitate to join a class—even one evening a week can do a lot of good.

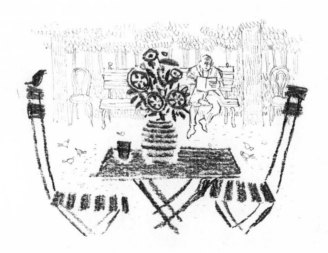

Composition

Deciding where to place even the smallest sketch or doodle on a scribbling pad involves composition. It is generally best to make your drawing as large as possible on your piece of paper. But there are many possibilities. Sometimes you may not even want the whole of the object on your paper. And there is no reason why the paper should be the same shape as the subject—it is not, for instance, necessary to draw a tall object on an upright piece of paper.

When you are drawing more than one object on a sheet of paper, the placing of each object is also important. Try as many variations as possible.

Before you begin a drawing, think about how you will place it on the paper—even a few seconds' thought may save you having to start your drawing again. The simplest subjects can make good pictures. Most of the buildings and settings used in this book would not get a second glance from a passer-by, but all are worth drawing and some have made interesting compositions.

Before starting an elaborate drawing, do a few very rough sketches of the main shapes to help you decide on the final composition.

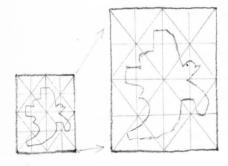

Rules are made to be broken. Every good artist is a good artist at least partly because of his originality; because he does what no one else has done before and because he breaks rules.

Every human being is unique. However poor an artist you *think* you are, you are different from everyone else and your drawing is an expression of your self.

What to draw with

Pencils are graded according to hardness, from 6H (the hardest) through 5H, 4H, 3H, 2H to H; then HB; then B, through 1B, 2B, 3B, 4B, 5B up to 6B (the softest). For most purposes, a soft pencil (HB or softer) is best. If you keep it sharp, it will draw as fine a line as a hard pencil but with less pressure, which makes it easier to control. Sometimes it is effective to smudge the line with your finger or an eraser, but if you do this too much the drawing will look woolly. Pencil is the most versatile of all drawing techniques, suitable for anything from the most precise linear drawing to broad tonal treatment. Of course, a pencil line, even at its heaviest, is never a true black. But it has a lustrous, pewtery quality that is very attractive.

Charcoal can be bought in various qualities and sizes. I advise short sticks since they are cheaper, and long sticks soon break into short sticks anyhow.

Charcoal (which is soft and crumbly) is ideal for bold, large drawings. But beware of accidental smudging. Never rest your hand on the paper as you draw. If you are used to pen or pencil this may at first seem difficult. But you will soon get used to it and, once you do, will find it adds freedom and spontaneity to your work.

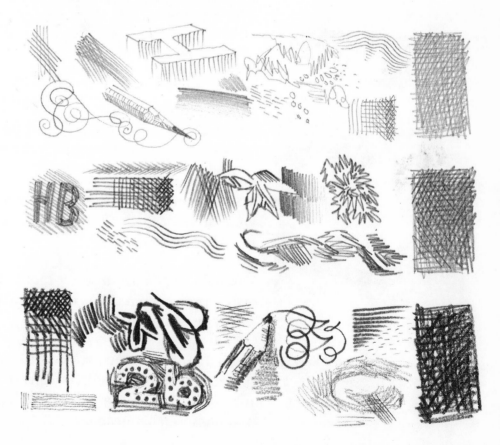

It is the most painterly of all drawing instruments. Smudging and erasing charcoal (traditionally done with kneaded pellets of bread) will give far more variety of texture than on a pencil drawing. And any part of the drawing you don't like can be removed with the flick of a rag. Take great care to preserve your successful drawings—by fixing them with spray fixative (now universally sold in Aerosol cans), and by attaching to them an overlay of tissue paper.

Conté crayons, wood-cased or in solid sticks, are available in various degrees of hardness, and in three colours—black, red and white. The cased crayons are easy to sharpen, but the solid sticks are more fun—you can use the side of the stick for large areas of tone. Conté is harder than charcoal, but it is also easy to smudge. The black is very intense.

Reed, bamboo and quill pens are good for bold lines. You can make the nib end narrower or wider with the help of a sharp knife or razor blade. This kind of pen has to be dipped frequently into the ink.

Fountain pens have a softer touch than dip-in pens, and many artists prefer them. The portability of a fountain pen makes it a very useful sketching tool.

Special fountain pens, such as Rapidograph and Rotring, control the flow of ink by means of a needle valve in a fine tube (the nib). Nibs are available in several grades of fineness and are interchangeable.

The line they produce is of even thickness, but on a coarse paper you can draw an interesting broken line similar to that of a crayon. These pens have to be held at a right-angle to the paper, which is a disadvantage.

Inks also vary. Waterproof Indian ink quickly clogs the pen. Pelikan Fount India, which is nearly as black, flows more smoothly and does not leave a varnishy deposit on the pen. Ordinary fountain-pen or writing inks (black, blue, green or brown) are less opaque, so give a drawing more variety of tone. You can mix water with any ink in order to make it even thinner. But if you are using Indian ink, add distilled or rain water, because ordinary water will cause it to curdle.

Ball point pens make a drawing look a bit mechanical, but they are cheap and fool-proof and useful for quick notes and scribbles.

Fibre pens are only slightly better, and (whatever the makers say) their points tend to wear down quickly.

Felt pens are useful for quick notes and sketches, but not good for more elaborate and finished drawings.

Brushes are most versatile drawing instruments. The Chinese and Japanese know this and until recently never used anything else, even for writing. The biggest sable brush has a fine point, and the smallest brush laid on its side provides a line broader than the broadest nib. You can add depth and variety to a pen or crayon drawing by washing over it with a brush dipped in clean water.

Mixed methods are often pleasing. Try making drawings with pen and pencil, pen and wash, charcoal and wash, or Conté and wash. And try drawing with a pen on wet paper. Pencil and Conté do not look well together, and Conté will not draw over pencil or any greasy surface.

Out of doors, fountain pens, ball points, fibre pens are of course easier to use than ordinary pens requiring a bottle of ink. Nowadays there are also fibre brushes on the market, so you can even do brush drawing with a 'fountain pen'.

What to draw on

Sketchbooks, made up from nearly all these papers, are available. Choose one with thin, smooth paper to begin with. Thin paper means more pages, and a smooth surface is best to record detail.

Lay-out pads make useful sketchbooks. Although their covers are not stiff, you can easily insert a stiff piece of card to act as firm backing to your drawing. The paper is semi-transparent, but this can be useful—almost as tracing paper—if you want to make a new improved version of your last drawing.

An improvised sketchbook can be just as good as a bought one—or better. Find two pieces of thick card, sandwich a stack of paper, preferably of different kinds, between them and clip together at either end.

Try as many different surfaces as possible.

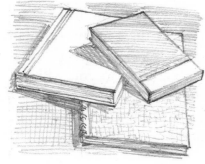

Ordinary, inexpensive paper is often as good as anything else: for example, brown and buff wrapping paper (Kraft paper) and lining for wallpaper have surfaces which are particularly suitable for charcoal and soft crayons. Some writing and duplicating papers are best for pen drawings. But there are many papers and brands made specially for the artist.

Bristol board is a smooth, hard white board designed for fine pen work.

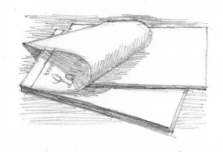

Ledger Bond ('cartridge' in the UK) the most usual drawing paper, is available in a variety of surfaces—smooth, 'not surface' (semi-rough), rough.

Watercolour papers also come in various grades of smoothness. They are thick, high-quality papers, expensive but pleasant to use.

Ingres paper is mainly for pastel drawings. It has a soft furry surface and is made in many light colours—grey, pink, blue, buff, etc.

Perspective

You can be an artist without knowing anything about perspective. Five hundred years ago, when some of the great masterpieces of all time were painted, the word did not even exist. But most beginners want to know something about it in order to make their drawings appear three-dimensional rather than flat, so here is a short guide.

The further away an object is, the smaller it seems.

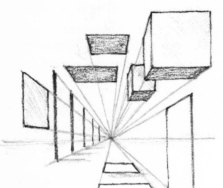

All parallel horizontal lines that are directly opposite you, at right-angles to your line of vision, remain parallel.

All horizontal lines that are in fact parallel but go away from you will appear to converge at eye-level at the same vanishing point on the horizon. Lines that are *above* your eye-level will seem to run downwards towards the vanishing point; lines that are *below* your eye-level will run upwards. You can check the angles of these lines against a pencil held horizontally at eye-level.

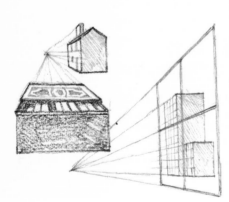

The larger and closer any object is, the bigger the front of it will seem to be in relation to the part furthest away, or to any other more distant object. Its actual shape will appear foreshortened or distorted. A matchbox close to you will appear larger and more distorted than a distant house, and if you are drawing a building seen at an angle through a window, the window frame will be larger and more distorted than the building.

If the side of an object is facing you, one vanishing point is enough (as in the matchbox drawing); but if the corner is facing you, two vanishing points will be needed.

It may even be necessary to use three vanishing points when your eye is well above or below an object, but these occasions are rare.

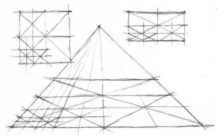

Diagonal lines drawn between the opposite angles of a square or rectangle will meet at a point which is half-way along its length or breadth. This remains true when the square or rectangle is foreshortened. You may find it helpful to remember this when you are drawing surfaces with equal divisions—for example, a tiled floor or the divisions between window panes—or deciding where to place the point of a roof or the position of windows on a façade.

You will tend to exaggerate the apparent depth of top surfaces because you know they are square or rectangular and want to show this in your drawing.

You can check the correct apparent depth of any receding plane by using a pencil or ruler held at eye-level and measuring the proportions on it with your thumb. If you use a ruler you can actually read off the various proportions.

One point to mention again: *all* receding parallel lines have the same vanishing point. So if, for instance, you draw a street this will apply to all the horizontal edges—roofs, doors, windows, lines of bricks, chimneys.

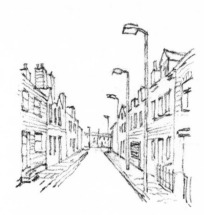

Interiors

The sketches on these two pages are principally concerned with perspective. The first of them has a single vanishing point, at the right-hand top edge of the sixth step. All receding lines below appear to run upwards; all above, downwards. Notice that above the eye-level/vanishing point the depth of the steps is not apparent.

The second drawing has a vanishing point just above the top of the left-hand letter in the rack on the far table. Notice that tone has been used to emphasise the pattern made by chairs and tables.

The third drawing has *two* vanishing points, both well beyond the drawing—one on the left, one on the right. Here, tone has been used to indicate the space *between* objects and their relative distance from the spectator.

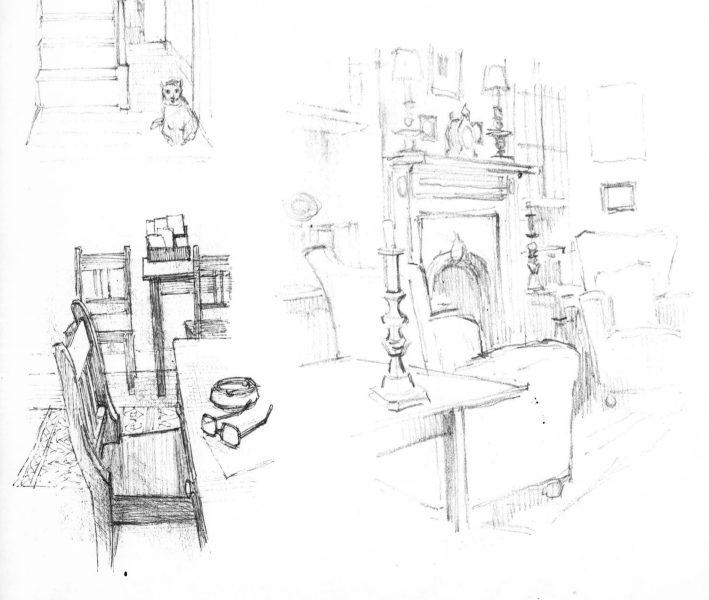

Here, the furniture, window recess, pictures, floor-boards, rugs (and patterns on rugs and bed-spread) all converge on the single vanishing point—just above the middle of the bed-head. All other lines are parallel with the picture-plane and run horizontally. Tone is again used to 'explain' space.

This sketch has two vanishing points: one (primarily for the cottages) is just outside the drawing to the right; the other (primarily for the window) is far to the left. Notice, though, that the thickness of the window-frame conforms to the vanishing point on the right; and the roof on the right and front of the centre chimney conform to the vanishing point of the window frame.

In this jumble of books, each closed volume has two vanishing points of its own, and the open one has three. Considering the total number of vanishing points, it is not surprising that I found this much the most difficult of these three drawings.

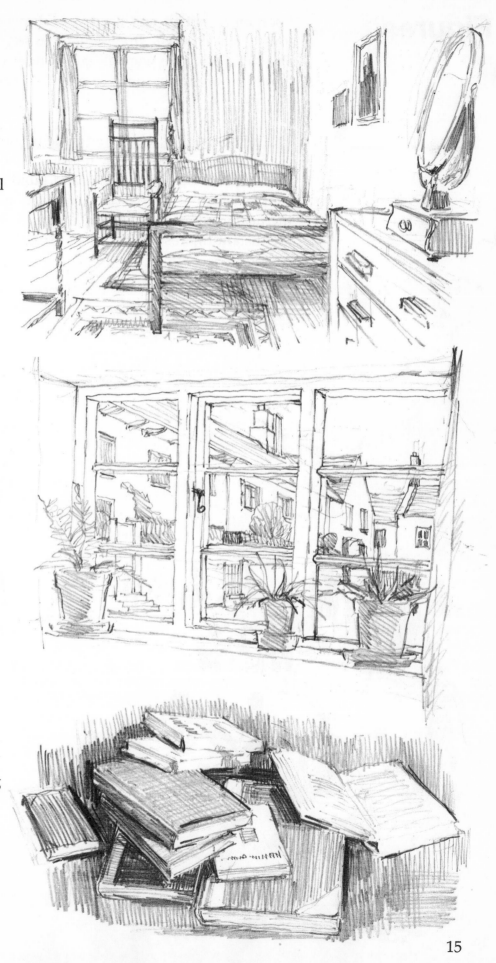

Figures

Look for essentials and keep your drawing simple. Don't invent, but observe. Draw what you *see*, not what you *know*. The drawings here were all done under conditions where the model was unlikely to move much—a good way to start with figures.

The perspective of tables and benches determines the placing of the almost diagrammatic figures in the café sketch (top). Individual character of stance and build are revealed in the simple sketch of people on a pier. The park sketch shows that the nearer a person is to you, the more detail is observable; the distant figures are stick-like—simple silhouettes.

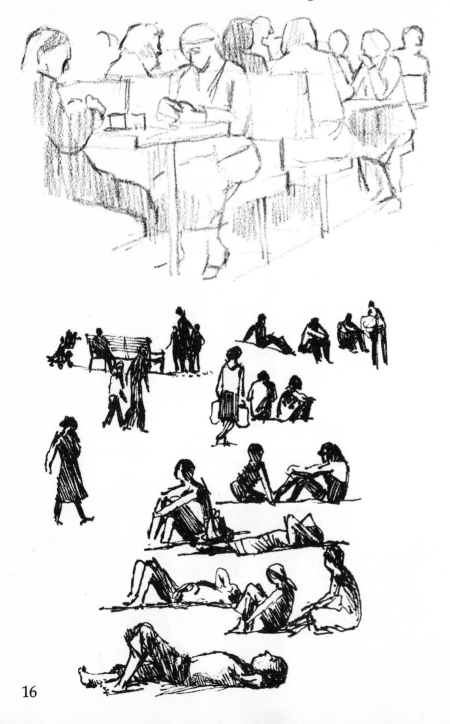

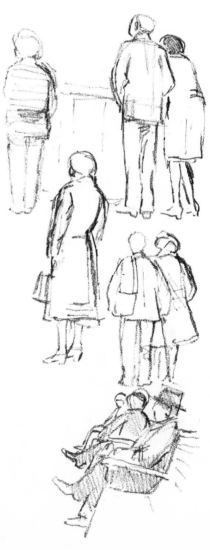

The sketches below on
this page, also of still
figures, bring out greater
detail and character than
those opposite.

The Spanish
stone-breakers were
moving, but the
movement was repetitive,
and not too difficult to
draw.

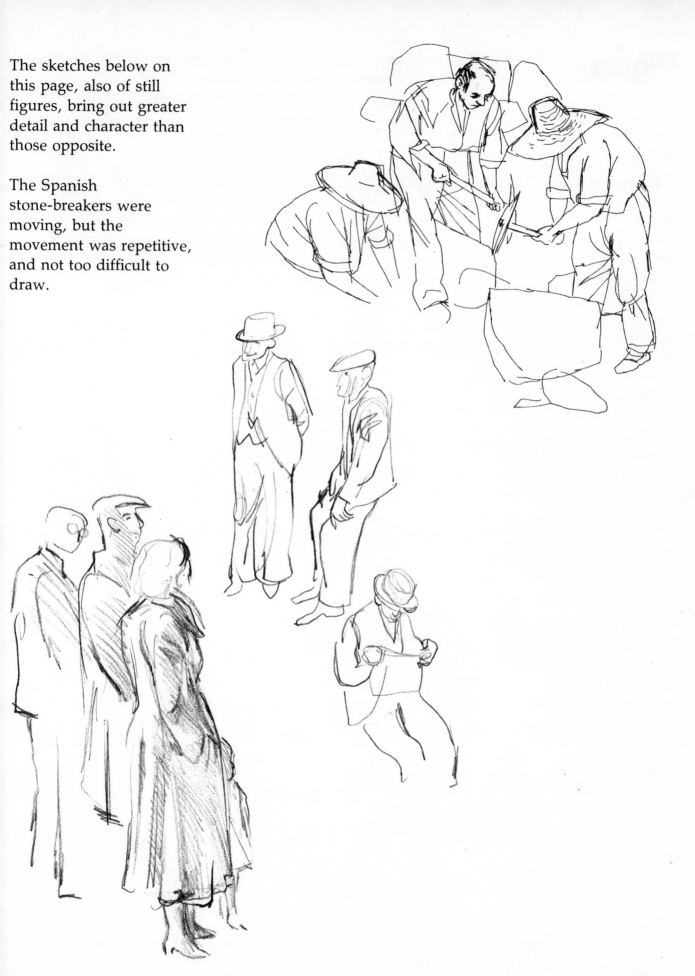

Trees

The first two drawings are constrasting versions of the same subject. The top one, drawn with a 2B pencil, stresses solidity and tone; the other, drawn with a fine fibre pen, concentrates on texture—the patterns of leaves and bricks.

The last sketch is a reminder that whatever you draw, perspective is involved. A line of trees marching across undulating ground diminish in size as they get further away.

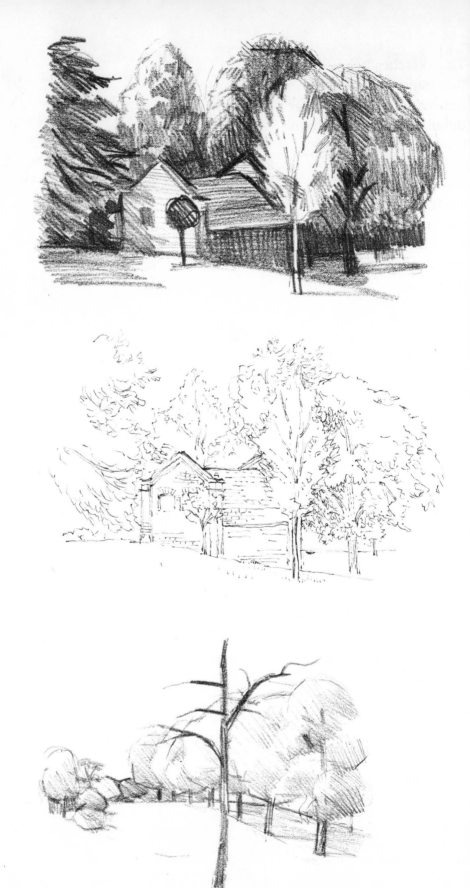

Skies

Clouds are not easy to draw, because they change shape rapidly. These sketches were all made with a carbon pencil. The first shows, through linear modelling, the solidity clouds can possess. The second, of clouds against the sun, brings out the halo effect of transparent edges in contrast with the darkness of the main bulk. Heavy clouds, building up for a thunderstorm in strong, dense shapes, are the subject of the third sketch.

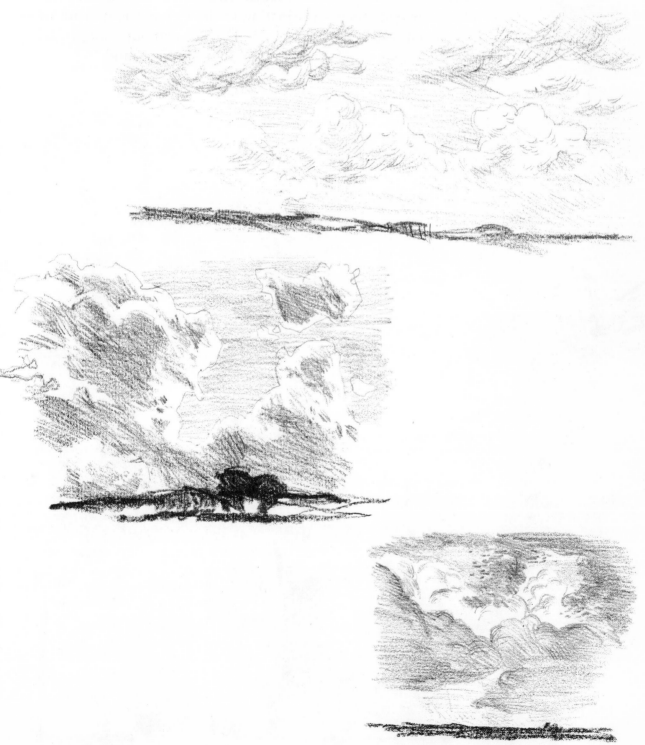

Still life

The most familiar objects can be fun and challenging to sketch. Try drawing a telephone from memory; then look at your own phone and draw it.

A bunch of keys provides unexpected shapes—and is not easy to draw.

Artists have always found bottles—with their various shapes, reflections and labels—fascinating to draw, but it is difficult to make even one bottle appear symmetrical without a lot of alteration, and re-drawing can produce smudges and lifelessness.

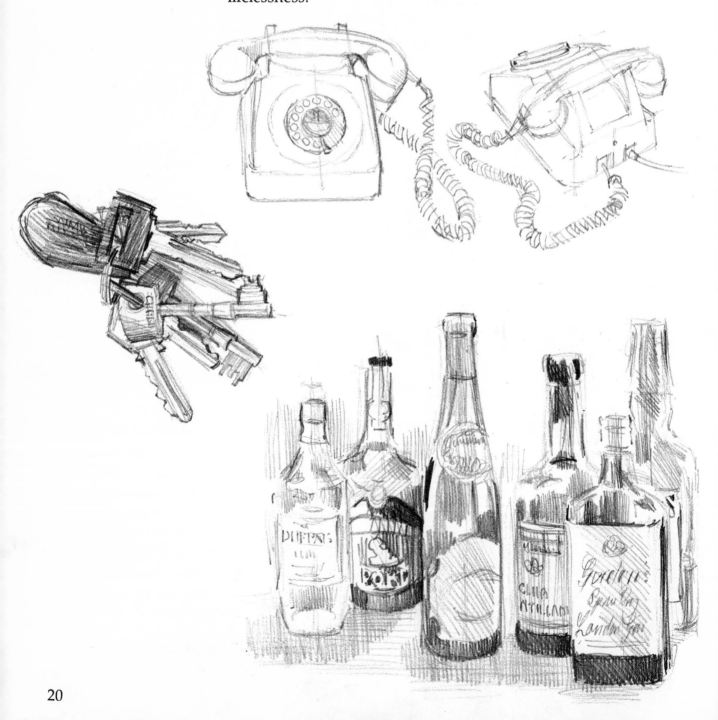

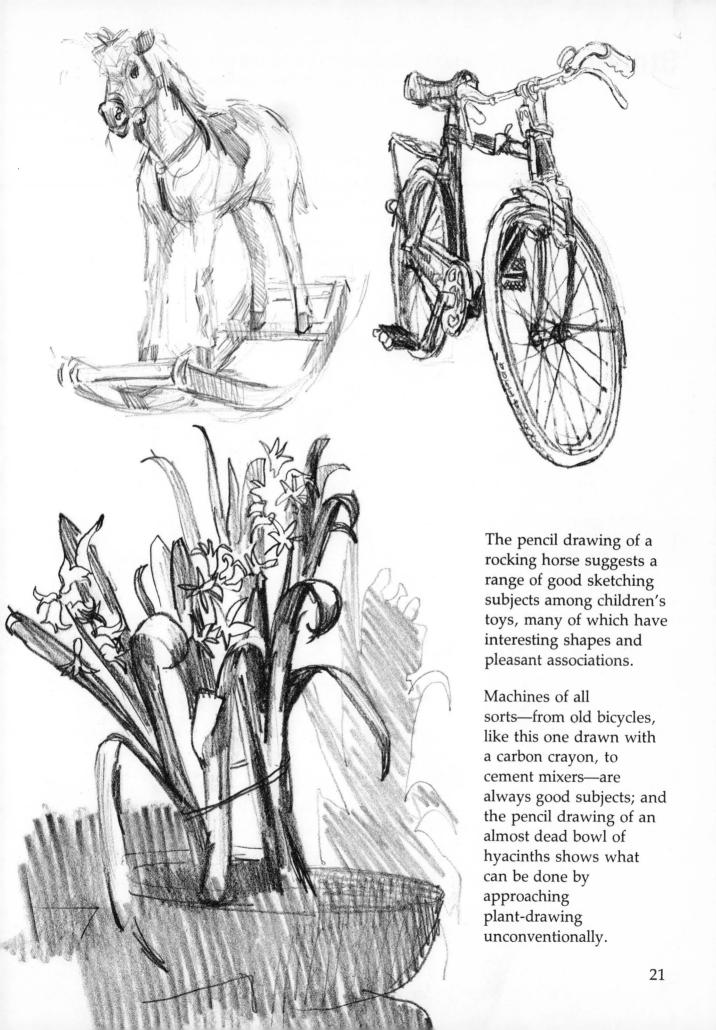

The pencil drawing of a rocking horse suggests a range of good sketching subjects among children's toys, many of which have interesting shapes and pleasant associations.

Machines of all sorts—from old bicycles, like this one drawn with a carbon crayon, to cement mixers—are always good subjects; and the pencil drawing of an almost dead bowl of hyacinths shows what can be done by approaching plant-drawing unconventionally.

21

Kitchens

The top left-hand scribble sorts out tones and composition of a breakfast still-life completed right. Notice that light and shade form the pattern.

By contrast the scales and fruit bowl, made with a ball point pen, rely on flat tonal contrast. Both these subjects were arranged first, but the hanging gadgets (below right) were drawn as they hung—it is the linear pattern that is interesting.

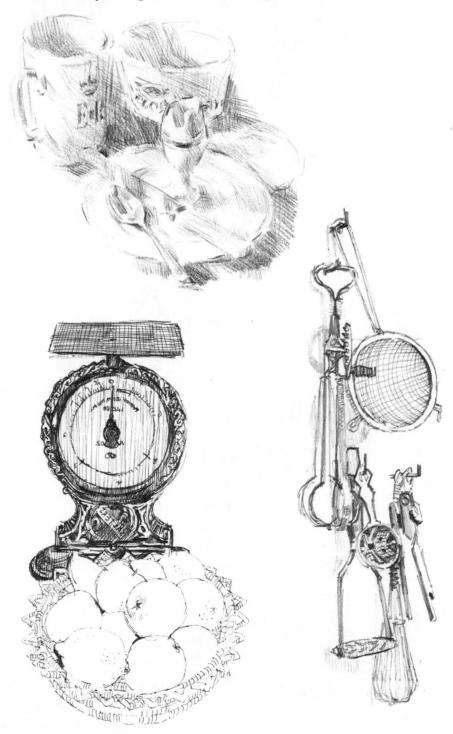

This page shows figures in a kitchen setting. Each sketch was done quickly. Speed is not a virtue in itself, but often your model will not remain still for long.

The first drawing, made with a ball point pen and a 6B pencil, reveals a flat dark-light pattern.

The right-hand sketch is speedily-drawn, in carbon crayon, with some indication of light and shade.

Light and shade are the main subject of the drawing below. I wanted to stress, for example, the light edge along the left shoulder and arm, rather than bring out detail in the drawing generally.

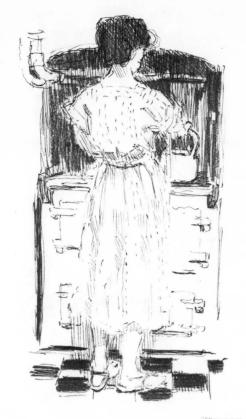

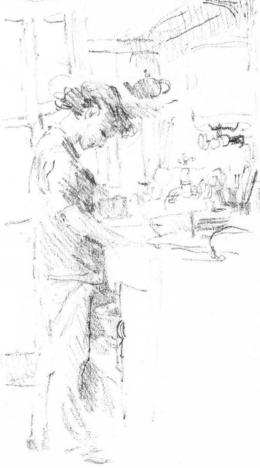

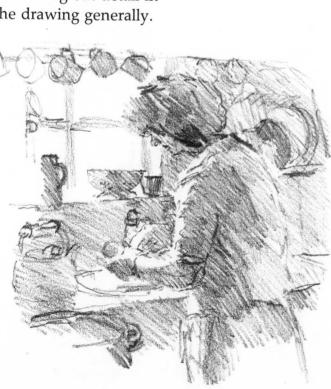

Gardens

The gardeners above and below were working—not posing for me. But their movements were so repetitive and slow that it was possible to add a bit to the drawing each time they came into the same position.

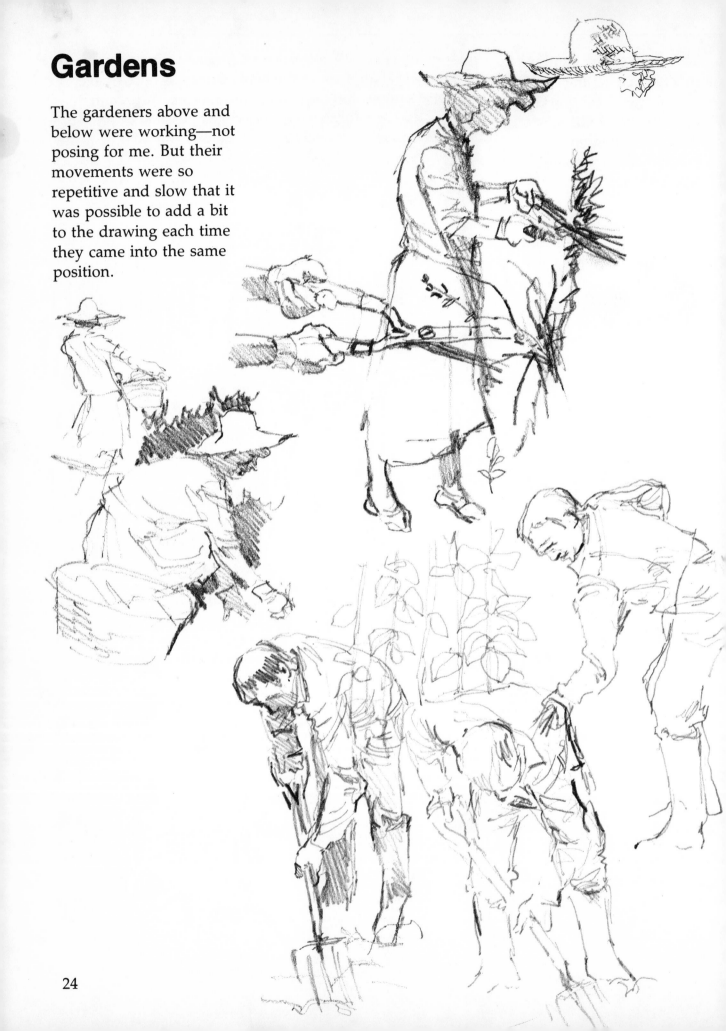

The drawing of a cottage garden in August is more elaborate and complete than most in the book. But even here I have gone for economy and sketching information. Tones and textures have been drawn as concisely as possible to prevent detail swamping the sketch. Notice there is still a lot of white paper showing.

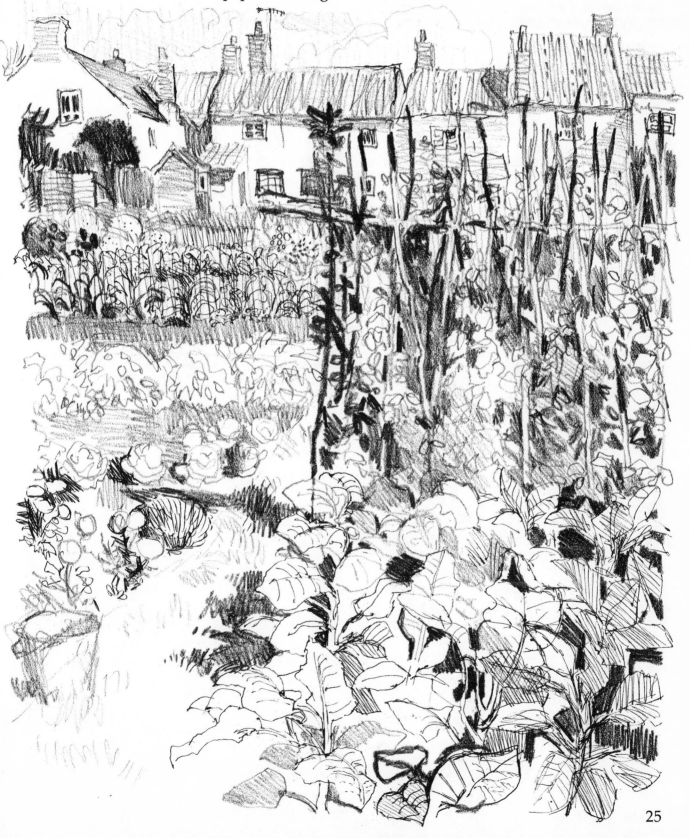

Portraits

One model that is always
available, willing to pose
for as long as you like,
and uncomplaining about
the result—is yourself.
All you need is a mirror.
Self-portraits are not
easy, because you know
your own face *too* well—it
looks *too* ordinary.
Nonetheless your own
face and body give you
endless opportunities to
experiment with
expression, technique and
lighting.

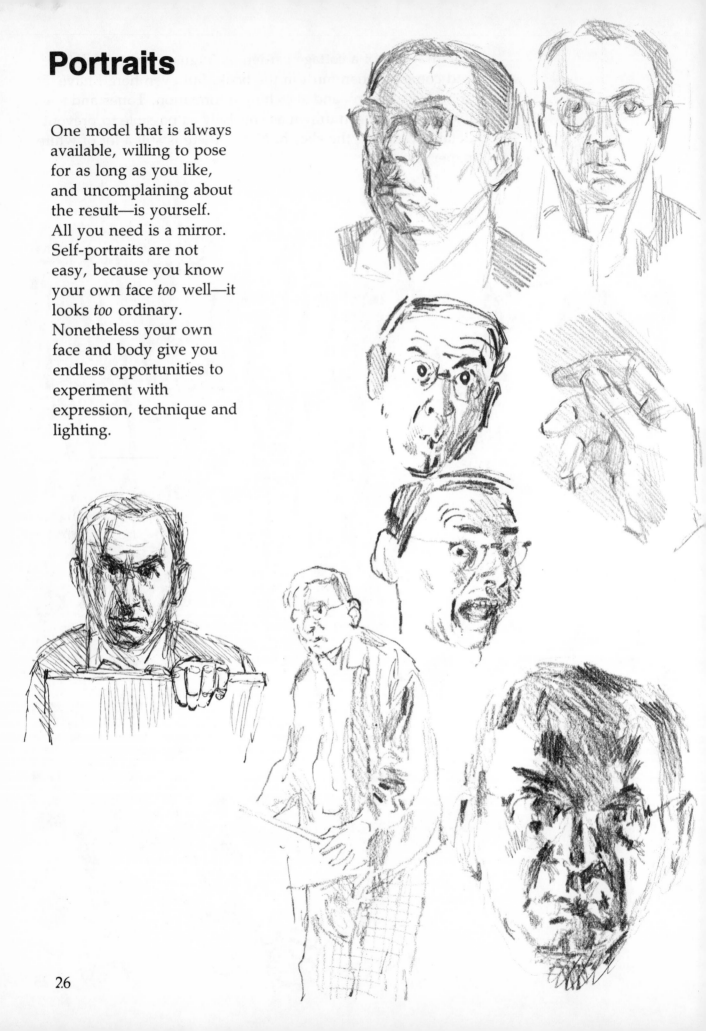

26

When someone has agreed to pose, try not to consider *their* feelings. Consider instead *your* drawing. (The man in the right-hand sketch was uninterested in my portrayal of him, but delighted with the drawing of his clock.)

If you draw figures do not over-concentrate on a single important point (the head, for example). Nothing is ever seen in isolation. Background is important, but need not be elaborate—the clock behind the man, the lamp beside the girl (the lamp also being necessary to explain the lighting in the drawing).

The varying depths of tone in the right-hand drawing provide variety and concentrate the interest of the picture in the upper part of the sketch.

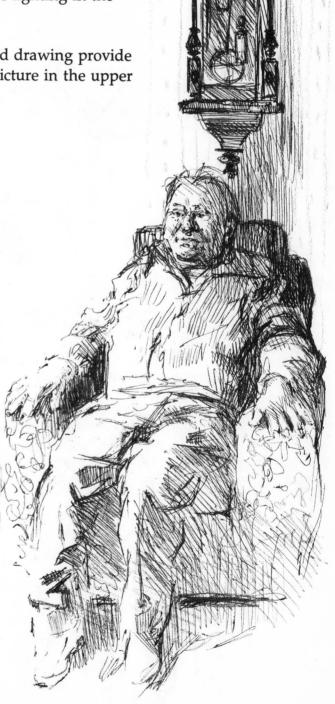

Children

However willing to pose, children find it hard to keep still. Try to find them something to do while you are sketching them. The three-year old above sat on her grandmother's lap, watching her draw. The boys throwing stones in a pond took up reasonably similar poses for long enough for me to make my sketch.

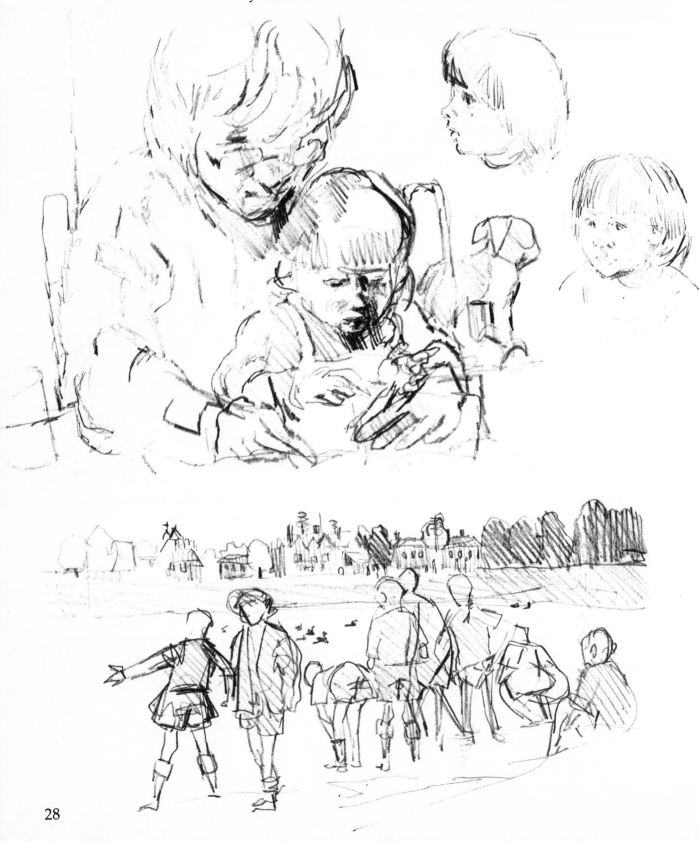

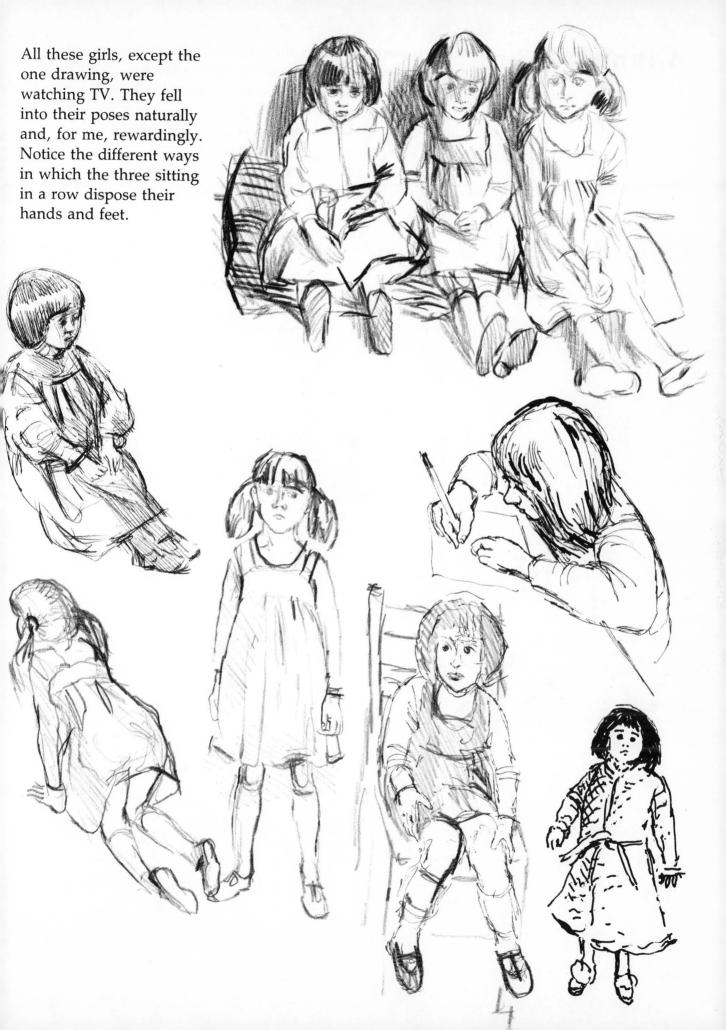

All these girls, except the one drawing, were watching TV. They fell into their poses naturally and, for me, rewardingly. Notice the different ways in which the three sitting in a row dispose their hands and feet.

4

Animals

Animals, too seldom stay still, and the sketchbooks of most animal artists are half-filled with hardly-started drawings. Be patient and draw quickly. The main purpose of sketching is to learn by looking and record what you can. Often, also, you can finish a sketch later when a pose is for some reason resumed. The horses here were feeding in a field, but came to inspect me when I started to draw. I sketched the large head from within touching distance before they withdrew again to the distance.

The black Labrador—asleep—was a better model.

The race-meeting was already breaking up—in continuous movement—when I started the bottom sketch, and even the car was gone when I finished.

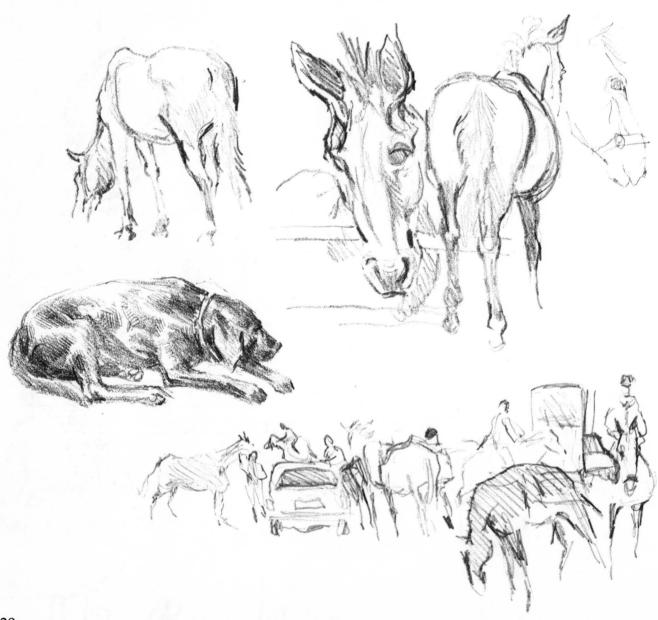

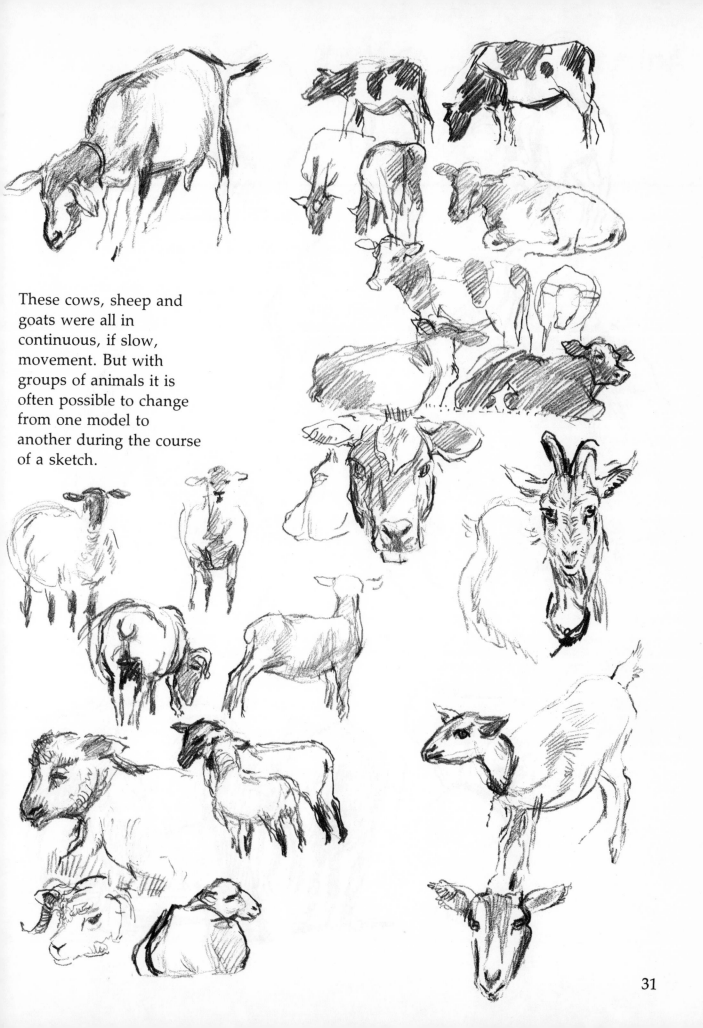

These cows, sheep and goats were all in continuous, if slow, movement. But with groups of animals it is often possible to change from one model to another during the course of a sketch.

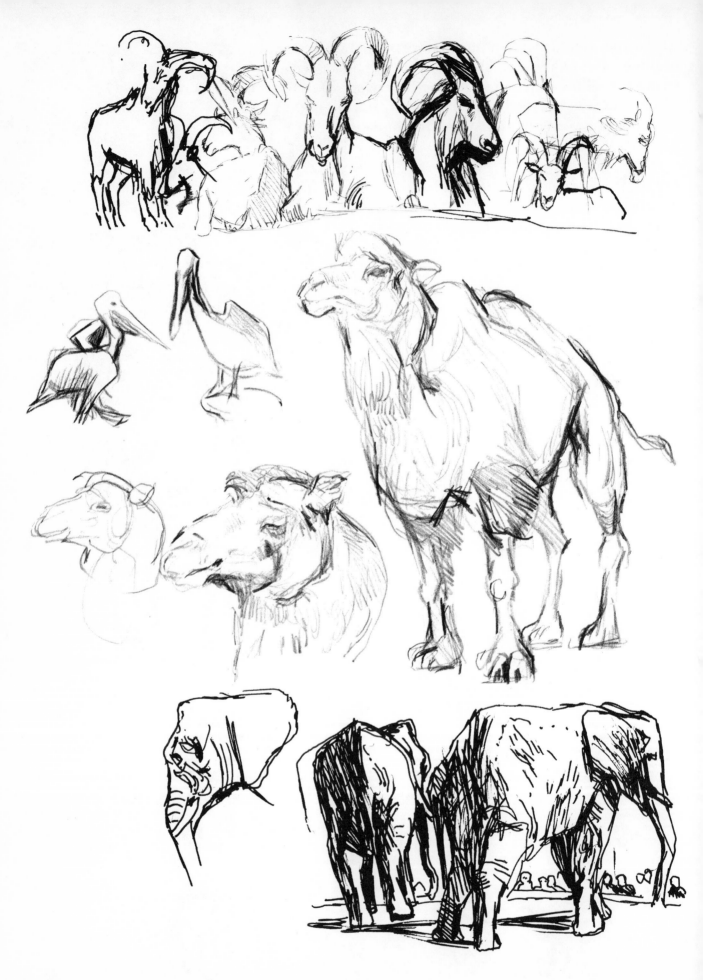

At the zoo, concentrate on one kind of animal if you are a beginner. Get to know its shape as well as possible before trying something different. Your tenth drawing of an elephant will be much better than your first, whereas your tenth zoo-animal drawing (if you switch from one to another, as I have here) may not be.

Try to draw complete animals, rather than details. If you are dissatisfied with part of your drawing, then draw that part again; as I did the camel's head.

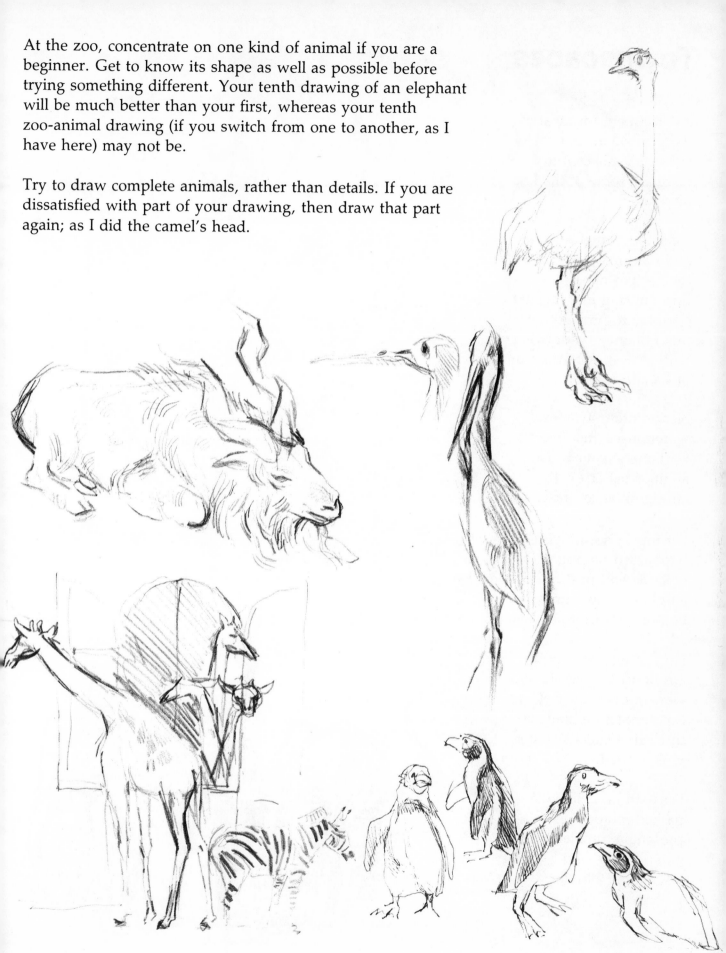

Townscapes

Towns, the daily environment for most of us, provide innumerable subjects for sketching. Here are some of the less obvious.

Near top: Street furniture and road markings (in themselves most unpromising ingredients) combine to provide the main theme of a drawing, with pedestrian stripes on posts and road.

Near bottom: Cranes, warehouses, factories and containers make a flat, angular pattern with strong tonal contrasts.

Far top: A seemingly haphazard placing of bollards and posts emphasises the jumble of building all around.

Far centre: Lamp post and tourists give life to a view of the Tower of London; and a glimpse through some stalls in a junk market.

Far bottom: A line of parked motorbikes presents a problem in perspective—and a fascinating all-over pattern.

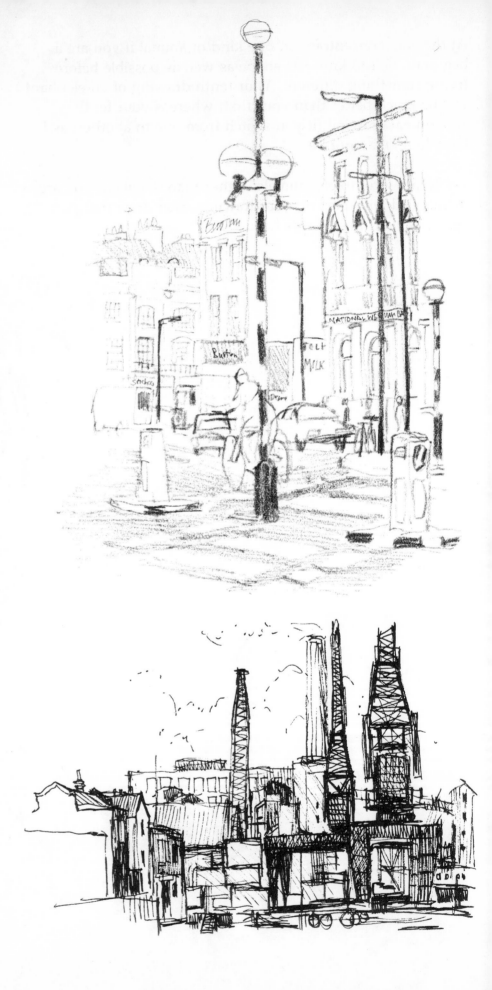

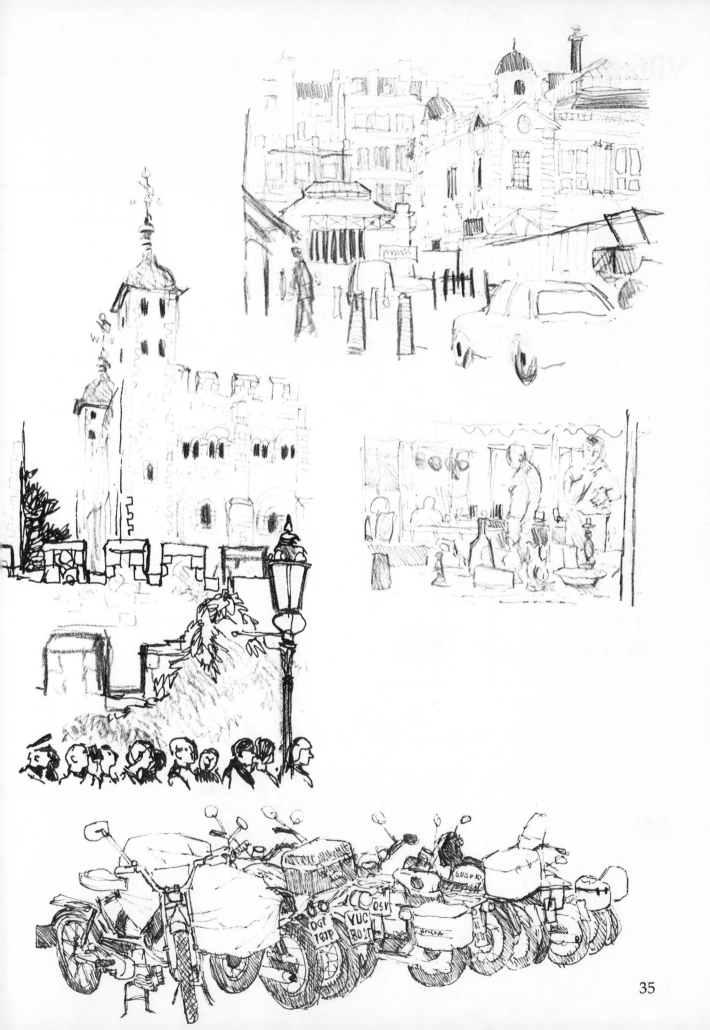

Villagescapes

Two Spanish village sketches, and (opposite) two English ones.

In the first on this page, I wanted to bring out the flat, mosaic-like pattern of the roofs, and therefore have not been over-concerned with perspective. In the second, tone brings out the pattern of a maize field, with buildings, palms and sea in the background.

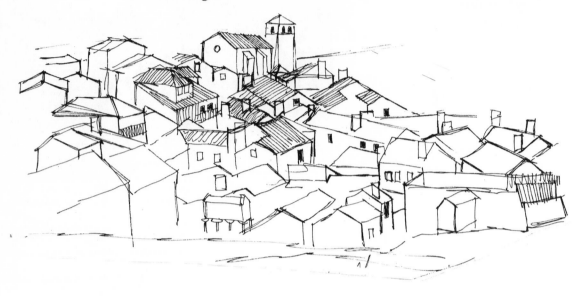

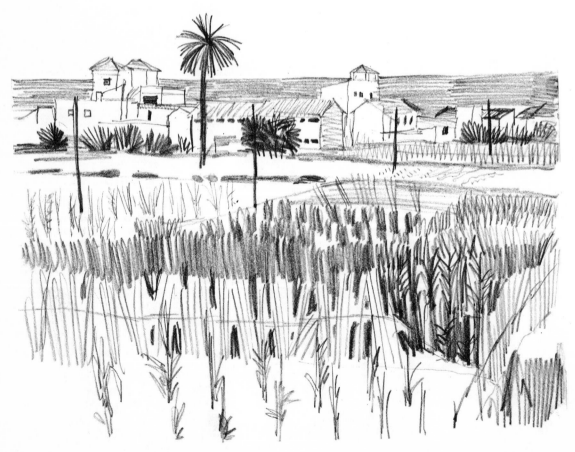

Textures of roofs, bushes and grass are stressed in the pencil and ball-point drawing above; and a pattern of small dark rectangles—windows, doors, chimneys— enlivens the receding line of buildings in the street-scene below.

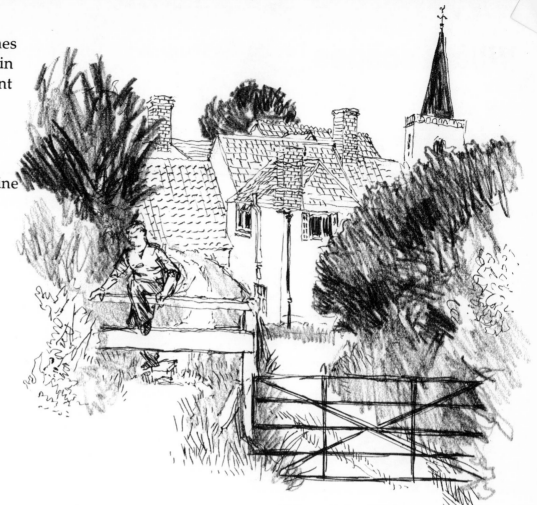

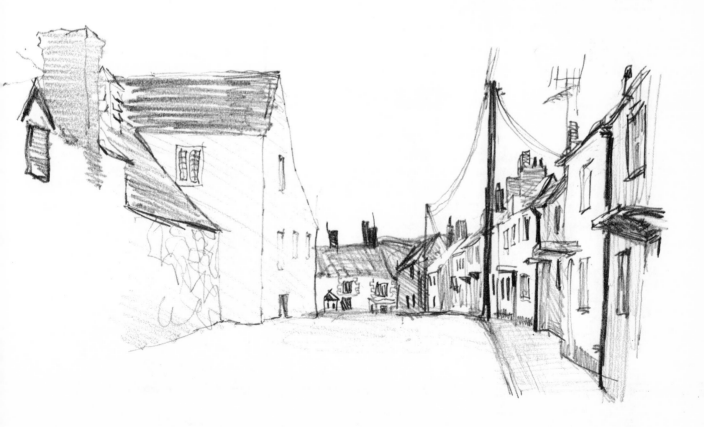

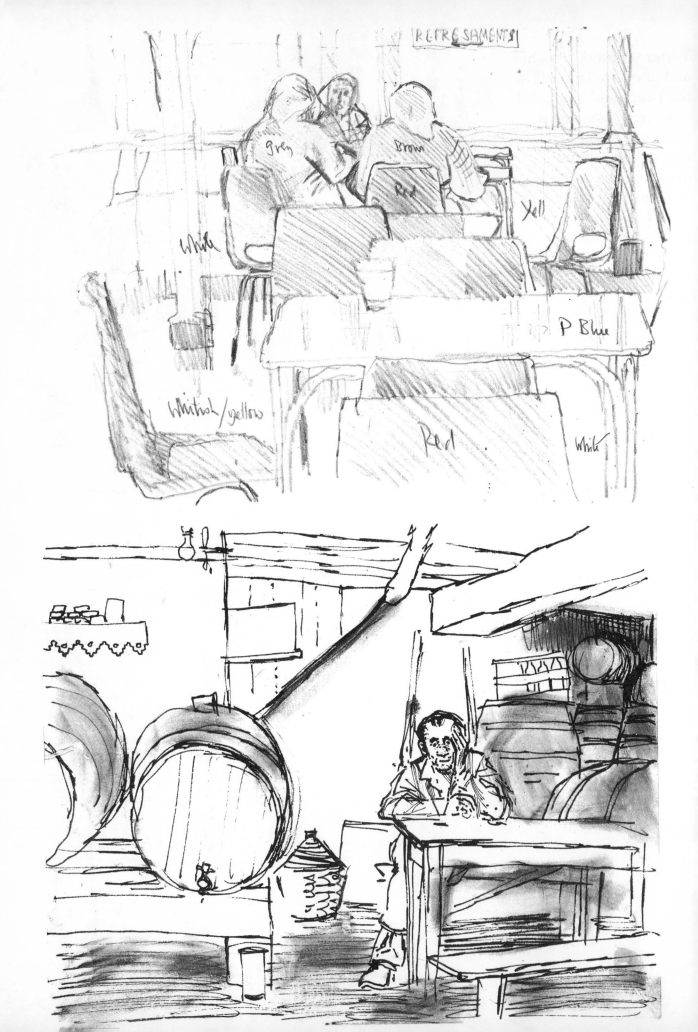

Figures in a setting

In three of the drawings here the figures take up little space, but are necessary to give life to the sketch. Notice their unusually high placing in the café sketch above left, and the interest and life they give to the Spanish bar drawings below left, and right. For the last three drawings, the subjects knew they were being sketched, and were most cooperative.

Notice the colour notes on two of the drawings, made in case I wanted to use them later for paintings. The others were drawn with a Rotring pen, smudged with a wet finger (left), and helped by litho chalk (right).

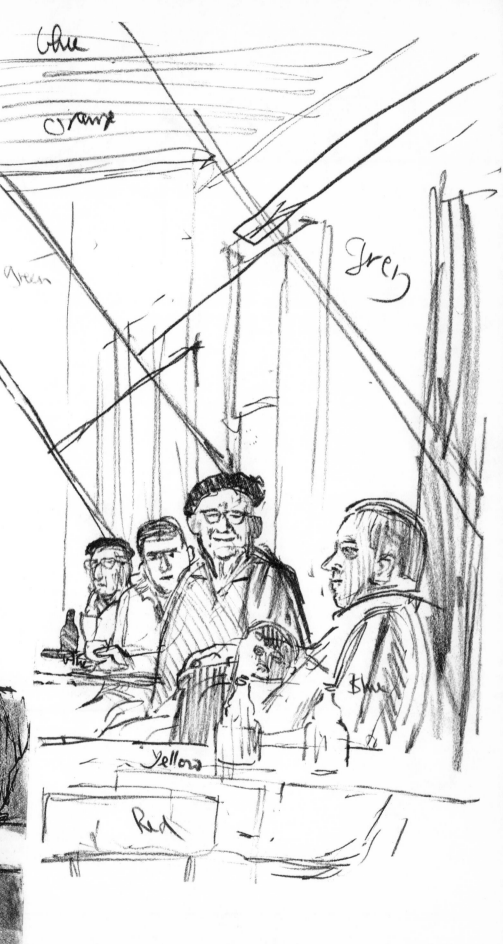

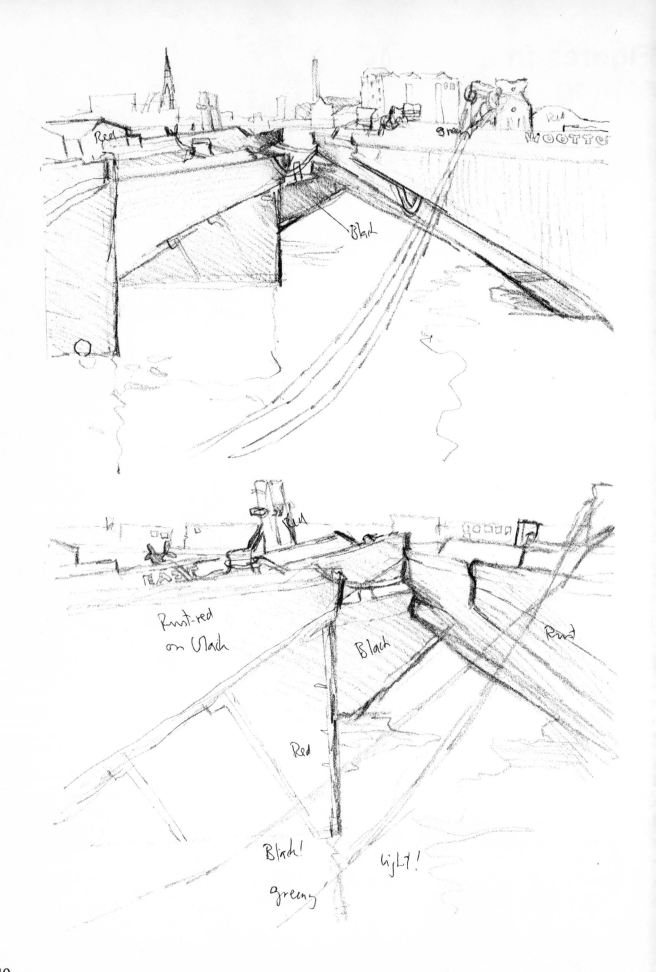

Boats

Sketching doesn't always produce drawings that are satisfying in themselves, but even the least satisfying has a value. The one above (left), of barges on a river, told me that I would have done better to attempt a more limited view of the central area, and I therefore did a better second sketch—with colour notes on it for a painting.

In the top (pencil) drawing here, I suppressed detail to emphasise the two-tone pattern of white paint against the black of the hull and the mud of the creek at low water. The contrasting ball-point below concentrates on line (rather than tone) in an attempt to capture the spidery nature of rigging, masts and spars; but the result would have been a thin, confused picture without the final addition of pencil tone. There are limits to what you can convey in a quick sketch, but many sketches can suggest the techniques as well as composition needed for a more studied drawing later.

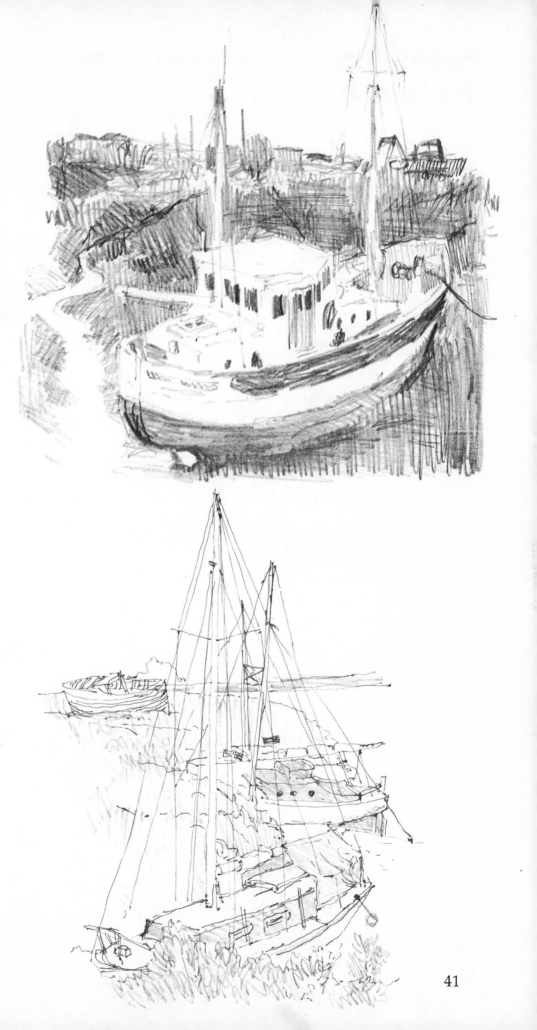

People on the beach

I recommend both the setting and subject of these pages as ideal for sketching. While sunbathing you can feel complacently that you are working; and on beaches people stay in one position for a long time, few taking any notice of a sketcher. The simple shapes of dunes, sea and horizon, outlines of headlands and beach shelters are excellent settings for unusual shapes of groups of figures. Groups, more than individuals, are rewarding for sketchers.

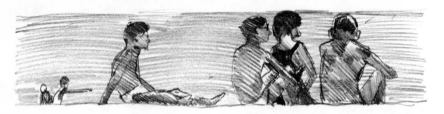

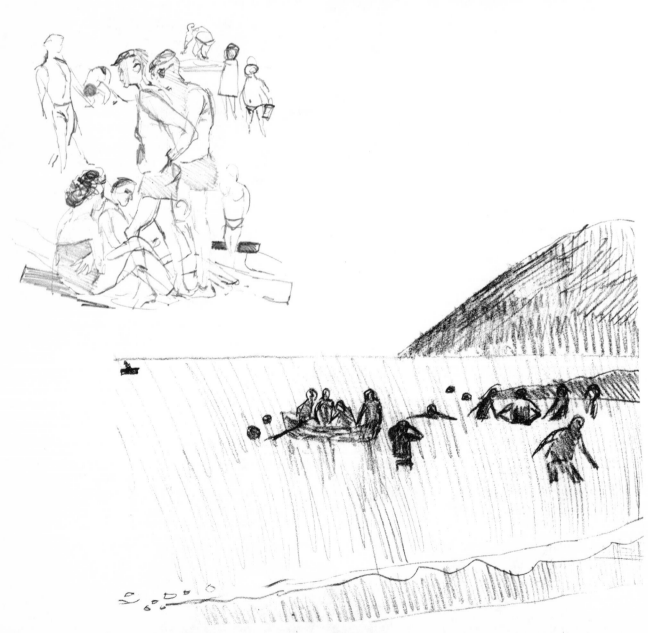

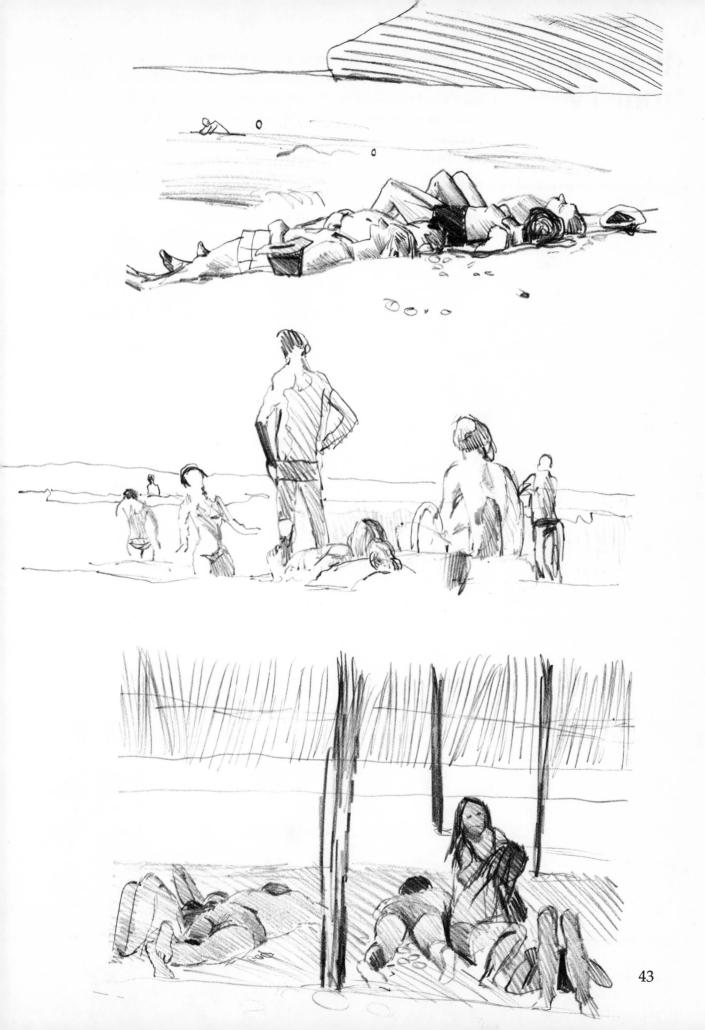

Sketching from TV

News-readers are obvious sitters—'posing' for quite long periods, usually full-face, and reappearing in the same pose another day. But the TV screen provides many other opportunities for the sketcher (music programmes, for example, when you can listen to the music too), and it is well worthwhile taking advantage of them. If you have only a limited time to complete your sketch, you are forced to select essentials and draw economically. None of the sketches on this page took longer than three minutes.

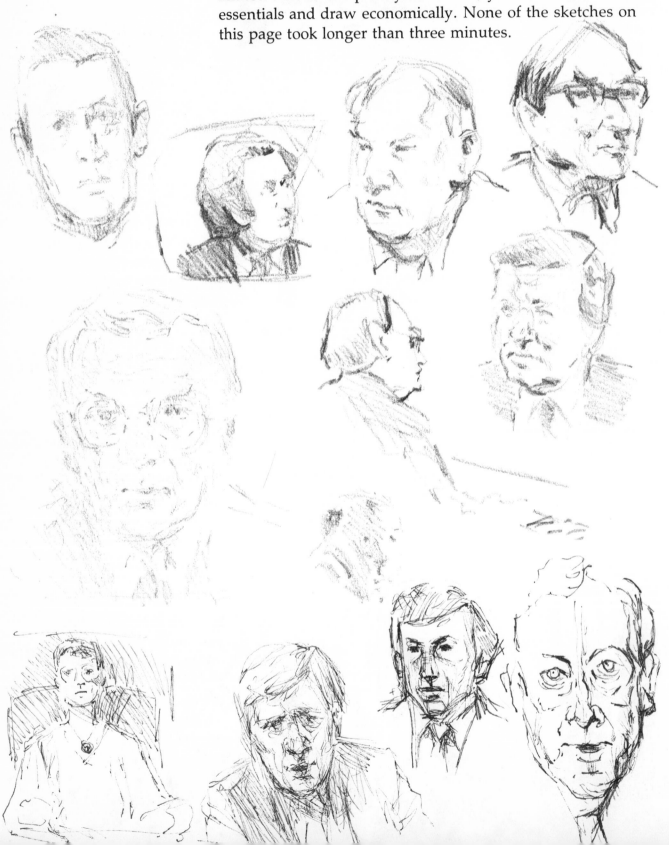

Sketching from photographs

Always draw from life if you can, but there are some subjects that you can only obtain, or obtain best from photographs.

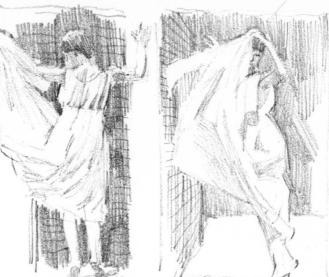

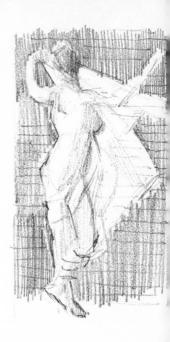

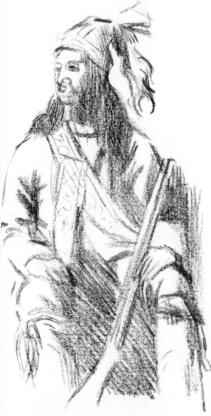

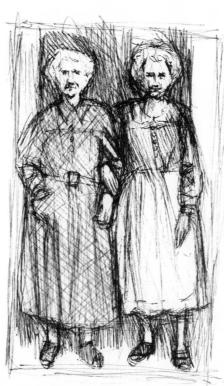

The pencil drawing above, of a classic of early photography (three photographs taken by different cameras at the same time), has a flavour of its own; and the other sketches (of a Red Indian photographed in 1860, an old snapshot, a mid-Victorian studio photograph, and Queen Victoria's official Jubilee portrait) show period details and expressions which are fun to reproduce. Try not to copy photographs, but to interpret them (sometimes distorting through selecting what you find is most interesting); and remember that they are flat and two-dimensional whereas you want your drawing to look three-dimensional.

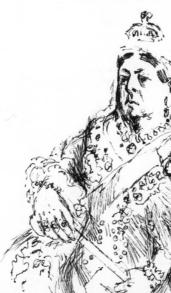

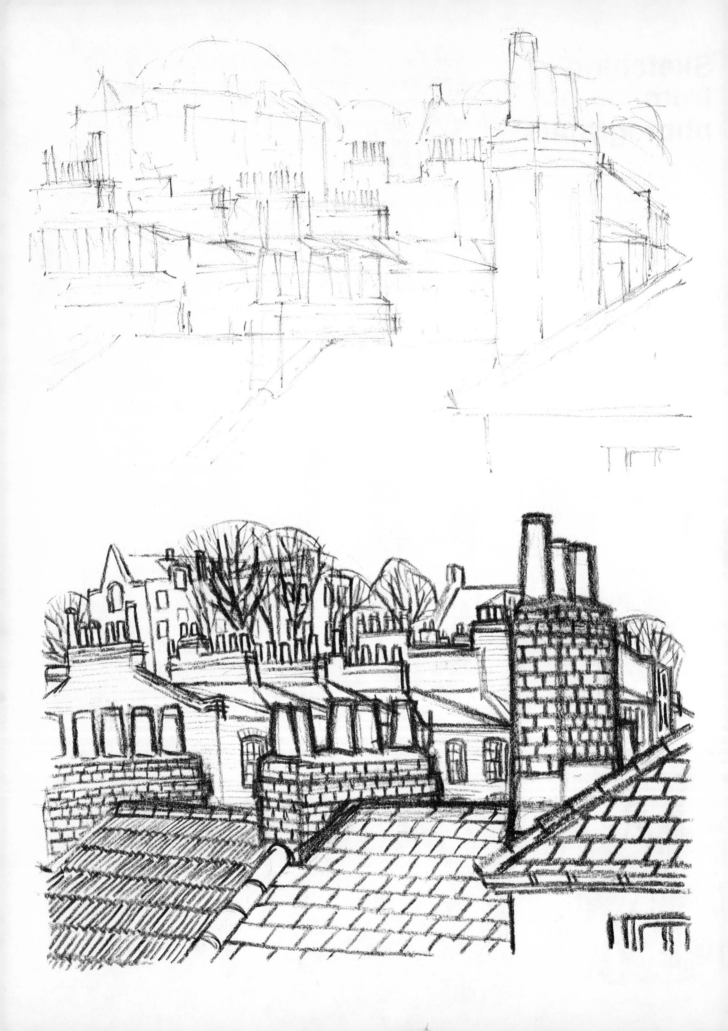

Three sketches of one view

The first drawing here is a preliminary pencil sketch of the main shapes of the composition—showing only essential angles and proportions, without details. It could have been completed by stressing the big shapes in the foreground and background, with other shapes gradually getting smaller from the front; but I followed different paths in the later two sketches. The second, a linear treatment with a soft crayon, emphasises the textures of bricks, tiles and windows, and strengthens the near roofs and chimneys to bring them forward. The third is a tone sketch, composed of strong, evenly distributed tones, closely following what I saw. I used a broad Rotring pen, smudging the tones in with a wet finger.

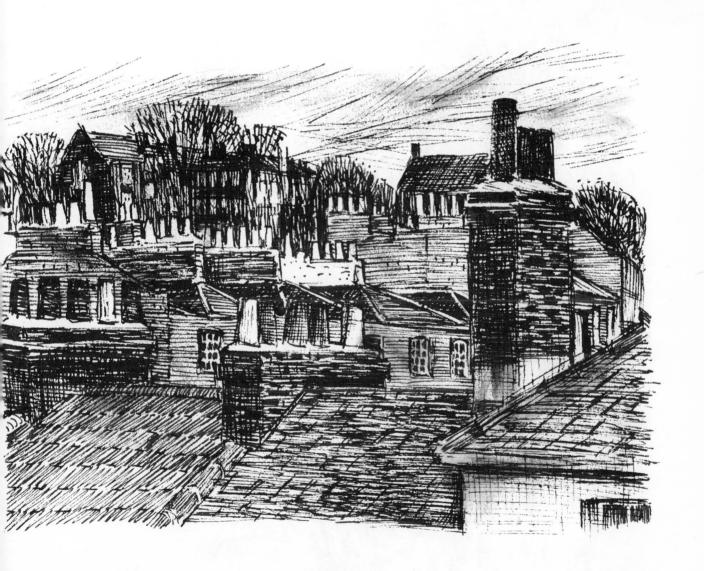

A finished work

In this sketch, I have tried to achieve a degree of simplification and abstraction greater than anywhere else in the book. It is a picture of bushes, small trees, clumps of nettles and overgrown hedges which made a beautiful but confused subject. However much I have simplified, every shape and tone is based on what I saw, and I had to look even harder at it, and at the whole view, than if I had treated my subject more realistically.

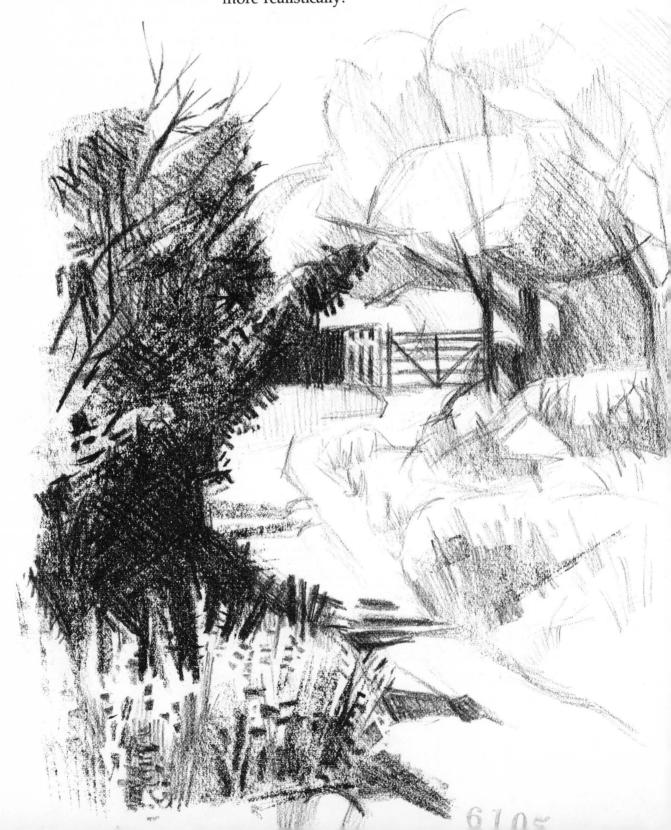